YOUR
FAMILY
DOCTOR

ARTHRITIS

Rheumatoid arthritis • Osteo-arthritis • Gout • Osteoporosis

DR VINOD WADHWA

wisdom
tree

Published by

Wisdom Tree
4779/23 Ansari Road
Darya Ganj, New Delhi-110002
Ph.: 23247966/67/68

Published by Shobit Arya for Wisdom Tree; edited by Manju Gupta; designed by Kamal P. Jammual; typeset at Icon Printographics, New Delhi-110018 and printed at Print Perfect, New Delhi-110064

I find by experience, that the mind and body are more than married, for they are most intimately united; and when one suffers, the other sympathizes.

— Lord Chesterfield

How true and how very expansive. Yes, when the body suffers from arthritis, the mind suffers from anxiety and depression and therefore, a need to understand arthritis is that much more important. Understanding brings control.

— Bonewitz

Contents

Preface

One never seems to appreciate the bounties of God. How often have you thought about the gift of refined locomotion that man has been bestowed with till you see a person who is unable to do so. Though diseases like rheumatoid arthritis are on the decline, yet age-related diseases are growing as we have a generation that has lived longer than any generation. The need to educate this group to prevent and manage disease conditions is the thought behind this tiny book.

"Let years wrinkle only the skin, not the soul."

Acknowledgements

Acknowledgements are due to *BMJ* (volumes read over the years), Davidson's *Principles and Practice of Medicine* and *Current Medical Diagnosis and Treatment*.

Joints: basic concept

When we talk of a joint, we usually think of an area where two bones meet, with room for movement. The first half of the statement is definitely correct but as far as the issue of movement is concerned, not all joints allow movement.

Let's discuss this enigma — the joint — in more detail. Simply said, a joint is an area where two bones come together (whether there is movement between them or not). Where two bones meet with an intervening cartilage or fibrous tissue that might fuse later on, there is

no possibility of movement. On the other hand, a joint, where two bones are held to by a thick layer of fibrous tissue or fibro cartilage, a very limited range of movement is possible. This type of joint can be seen in the bodies of the vertebra where the disc space is occupied by the fibrous tissue.

The layman's concept of a joint where free movement is evident is called a synovial joint. Here the two ends of the bones are covered with a modified tissue called the articular cartilage (which is actually pretty hard). These two articular surfaces move on each other in a fluid-filled space, called the synovial space. The two ends of the bone are covered by a fibrous covering, called the fibrous capsule. This helps in keeping the joint together and encloses the joint space. A membrane layer lines the entire joint space other than the articular surfaces. This produces the synovial fluid that permits movements to become possible and it is called the synovial membrane.

When we talk of arthritis, it is primarily this synovial joint which is most often affected, though other joints could also be involved to some extent. Let us now discuss arthritis in greater detail.

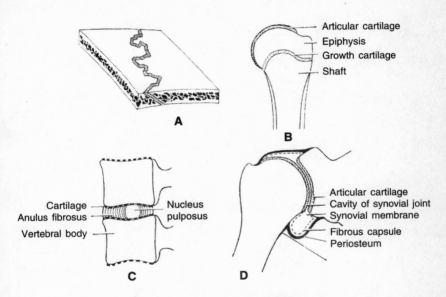

Figures A, B, C, D show four types of joints.

Rheumatoid arthritis

This is a disease which causes swelling of the joints, followed by destruction and eventual deformities in multiple joints. Thus, in medical jargon, it is a chronic inflammatory, destructive and potentially deforming polyarthritis. The joints involved are synovial and the disease is symmetrical, involving primarily the peripheral joints. The disease shows periods of improvement or regression, interspersed with periods of great discomfort and exacerbations. The disease also involves parts of the body other than the skeletal system, thereby compounding the patient's woes.

The disease affects about 2-3 per cent of the population with women suffering three times as often as men do. Most female patients are found in their thirties or their forties but cases could manifest at any age group. Interestingly, a greater incidence is seen in urban areas as compared to rural areas, suggesting an element of environmental factors.

Criteria for rheumatoid arthritis
(American Rheumatism Association, 1988)

- Morning stiffness
- Arthritis of three or more joint areas
- Arthritis of hand joints
- Symmetrical arthritis

Duration of six weeks or more
- Rheumatoid nodules
- Blood rheumatoid factor positive
- Radiological changes

If any four criteria are positive, the diagnosis of rheumatoid arthritis is confirmed.

Presentation

The disease presents in a very slow, insidious fashion with the patient complaining of joint pain and stiffness. Swelling of a number of joints which is usually symmetrical, often accompanies the pain and stiffness. Though morning stiffness is one of the commonest presenting symptoms, people do complain of pain during movement of joints initially. Usually the small joints of the fingers and the toes are involved at first. The terminal finger joints do not swell up but the proximal joint swelling causes the fingers to take up a spindled look. Slowly and gradually, the other joints, especially of the wrists, elbows, shoulders among the upper limbs and the knees and ankles among the lower limbs, get involved. The disease involves all the synovial joints and it is not rare to see the temporo-mandibular joints (jaw) to become painful and stiff, thus making chewing painful. Neck pain and neck stiffness due to vertebral column involvement aggravate the patient's discomfort.

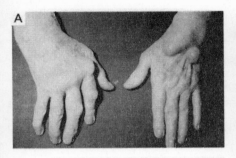 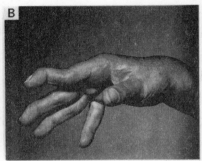

The hands in rheumatoid arthritis.

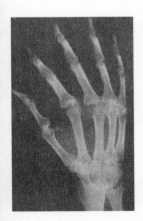

The involvement of the hip joint is seen in severe cases.

- 70-75 per cent present insidiously
- 15-20 per cent present dramatically
- 10 per cent with symptoms other than joint symptoms

Note the loss of joint space, erosion of the metacarpal heads and disorganisation of the wrist.

As discussed, most cases (70-75%) present with a slow-growing pain, stiffness and swelling of the joint over weeks and months. Nearly15-20 per cent of the cases display sudden swelling and pain of a few joints. Others present in a manner which is atypical. About 10 per cent of the cases present with fever, weight loss, unexplained malaise and loss of strength and increasing tiredness.

Diagnosing these 10 per cent cases is usually a little difficult as most such cases are thought to be suffering from infectious diseases or some malignant disease.

Slowly and gradually, the disease becomes older and tends to involve the muscles, the tendon sheaths and the joint structure, thus increasing the pain, joint instability and deformities of the joints. Initial deformities can be corrected but as the disease becomes more chronic, the tissues undergo permanent changes and cause complete disorganisation of joint spaces and tissues around them.

All these changes are progressive, causing the muscles to contract and subsequently leading the joints to subluxate or a sort of 'come off

the lock they are in'. This joint deformity then allows the muscles a little more scope for contractures, thus leading to a joint that is both grossly deformed and immobile. Some deformities are given names derived from Nature, but somehow one can't be poetic about abnormal shapes.

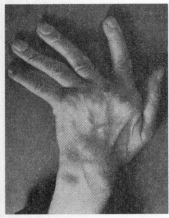

The 'trigger finger' arthritis.

One interesting condition is the 'trigger finger' in which the finger is bent as if it is ready to shoot. It gets stuck and can be straightened only with help. This is caused by nodules in the tendon sheaths which cause flexion of the fingers. Swelling of the tendons and their covering could lead to swelling and pain when moving the muscles. This condition is called tenosynovitis.

Rheumatoid arthritis and the eye

Rheumatoid arthritis is a disease involving many systems. The eye is a target organ and rheumatoid arthritis could create a whole lot of diagnostic problems for the ophthalmologist. The white part of the eye, called the sclera, is most often involved. The covering of the sclera could show a mildly painful condition which presents with a red, raised lump but no visual impairment. The deeper the tissue involved, the greater is the pain. The eye then becomes congested and painful and this condition is termed as 'scleritis'. The problem becomes complicated as the adjacent tissues, like the iris become swollen,

leading to iridocyclitis. The sclera could become thin and weak, and thus bluish. This condition is called scleromalacia. If this condition does not abate, it could progress to further thinning and melting away, causing areas of sclera to disappear altogether. Such an extreme condition is fortunately rare and is termed as scleromalacia perforans.

One could get a sceral graft done or if the situation is grim, the eye has to be enucleated or removed.

Another less grave yet irritating condition is the 'dry eye' or keratoconjunctivitis sicca. In this, the eye secretion dries up, causing an intense sensation as felt during the presence of a foreign body in the eye. This causes grittiness, irritation and uneasiness. Lacrimal secretions can be assessed by a test called Schirmer's test in which a special blotting paper is placed in the eye, under the lower eyelid for some time and the extent of wetness of the paper reveals the extent of dryness.

Artificial tears have to be used frequently to achieve some degree of comfort. Such eyes are prone to infections and corneal ulceration.

Effect of rheumatoid arthritis on heart and blood vessels

Rheumatoid arthritis might not involve the heart very often, but it does involve the covering membrane of the heart. This could cause collection of a fluid called pericardial effusion and if this effusion becomes very large, it could hamper the movement of the heart, causing constrictive pericarditis. Rheumatoid arthritis does cause quite a lot of damage to the blood vessels though. At times the blood vessel wall

could show a diffused swelling, thereby reducing blood flow. This is called necrotising vasculitis.

Entrapment of nerves in inflamed and swollen fascial sheaths could cause severe pain and paralysis-like conditions. These conditions are called entrapment neuropathies. The commonest type is median nerve compression in the wrist called 'carpal tunnel syndrome'. Rarer entrapment could be 'tarsal tunnel syndrome'. Nerves of the hand could be involved in peripheral neuropathy, causing the 'glove sensory loss'. A similar involvement in the legs adds up to cause the 'glove and stocking' numbness.

Managing rheumatoid arthritis

Investigations

The blood picture in rheumatoid arthritis could show a decrease in haemoglobin content (anaemia) with an overall decrease in platelets, called 'thrombocytopenia' and white blood cells, called 'neutropenia'.

The *rheumatoid factors test* is a fairly reliable test. This test could be false negative in the first two years of rheumatoid arthritis but is usually positive in about 70 per cent of the cases of rheumatoid arthritis.

The *synovial fluid analysis* is a more recent and a direct test to tap

synovial fluid from an effusion. In rheumatoid arthritis, the characteristic findings would be:

Visual examination
- *colour:* yellow
- *appearance:* cloudy
- *microscopic cell count:* 2,000 to 40,000 cells/cubic mm

A most reliable test is *arthroscopy.* As newer and newer diagnostic tools are available, specific diagnosis is becoming easier. One can pass a small arthroscope to view the finer details of the joint and the disease-induced changes. In rheumatoid arthritis, one can see the swelling and congestion of the synovial membrane, followed by thickening and hypertrophy. This is followed by weakening and small erosions of the articular cartilage.

There was a time not long ago when skiagram or X-ray was the finest investigative technique available. Not any more, though it still is the most easily available and possibly cost-effective technique. Newer techniques like the CT scan and the MRI are used for obtaining more details.

How to manage rheumatoid arthritis

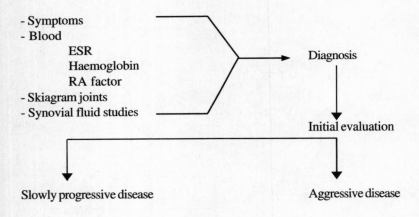

- Symptoms
- Blood
 ESR
 Haemoglobin
 RA factor
- Skiagram joints
- Synovial fluid studies

Diagnosis

Initial evaluation

Slowly progressive disease

Aggressive disease

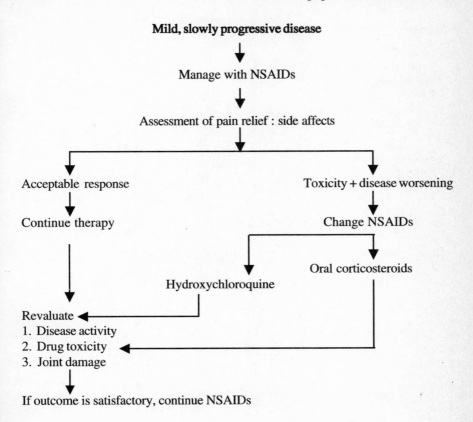

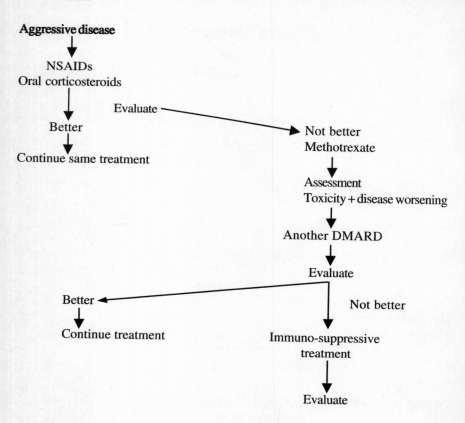

Aggressive disease

NSAIDs
Oral corticosteroids

Evaluate

Better

Continue same treatment

Not better
Methotrexate

Assessment
Toxicity + disease worsening

Another DMARD

Evaluate

Better

Continue treatment

Not better

Immuno-suppressive
treatment

Evaluate

Knowledge is knowing facts; wisdom is knowing what to do with the facts you know.

Through years and years of research, failures might have faced us squarely in our face, but the spirit of mankind and its innate quality to reach for excellence have provided us with more than one treatment mode and schedule. With a sense of despair, one could say that we still have no curative treatment, but at the same time, a conservative medical approach offers a reasonably good, long-term benefit to the patient.

In a nutshell, one should first look at the aims of the treatment and then, how best they can be achieved. I guess it would be best to discuss this with the patient and to plan a schedule accordingly. Usually most patients would be looking for

- Reduction in pain and swelling
- Preservation of the joint function
- Prevention of typical arthritis-related joint deformities

All in all, each patient would require a specifically designed treatment regimen. There can be no copybook treatment. In this, I

normally tell the patient, *"Some people think in terms of problems and others in terms of solutions."* So, let us start looking for solutions and this is possible only if help is asked for, received and accepted with thanks.

Patient's participation

In no other condition is the patient's participation in managing the disease more important.

- *Rest and exercise*: A fine balance between rest and exercise has to be achieved. In severe articular (joint) disease or systemic condition, complete bed rest is advisable. As the general condition responds to treatment, one could increase the periods of activity. Once one is back to normal or near normal, exercise then becomes the most important measure as a conservative therapy of this disease. The main aim of exercises would be to improve joint mobility and increase muscle strength. It could start with passive exercises before moving on to isometric exercises. Increasing resistance exercises can be attempted, depending on the patient's condition.

- *Joint care*: As this is primarily a disease of the joints, extra care needs to be taken of all the synovial joints. More importantly, weight-bearing joints should be taken care of, lest deformities arise. Intelligent use of crutches and braces could be of great benefit. Articular rest of an inflamed or sore joint could help achieve early recovery. Heat treatment was the mainstay of ancient treatment schedule and most people still find plenty of relief from heat treatment.

- *Try to make the most of a difficult situation and you'll make your world a happier place to live in.* One cannot deny that the moment

a patient thinks he/she is suffering from arthritis, then he/she is gripped by anxieties, and slowly and gradually, depression and apathy set in. It is such an attitude that causes greater pain and suffering than the actual condition. Thus, the endeavour of every physician should be to take care of the patient's psyche first of all. Proper psychiatric help, if deemed necessary, should be provided. Here the doctor–patient relationship comes into play and the more the understanding is between the two, the easier is the patient's ability to fight back, psychologically. The situation calls for a very carefully–planned treatment schedule, which should be shared with the patient. At no stage should anything be held back but great care should go into the emotional aspect of handling the patient. Medicines to relieve pain and swelling would suddenly seem to work better the moment the patient accepts the situation gracefully. Once this is taken care of, the next part of the journey becomes easier.

Drugs, drugs and more drugs

A long list of drugs is currently in use for the management of rheumatoid arthritis. Some drugs are in vogue because of their safety and others, because they are more efficacious. A few medicines are being discussed here in some detail.

Non-steroidal anti-inflammatory drugs or NSAIDs

Aspirin: One of the least expensive drugs under the NSAID group, it is a potent anti–inflammatory agent. The only problem is that some

people show severe allergic reaction to aspirin. Contraindication is seen in asthmatics and in people with gastric duodenal ulcers. Maximum dosage which provides relief but does not induce toxicity (upto 4–5 gms daily, usually) can be given. Dosage titration is best left to the physician.

In case aspirin is not tolerated by the patient, one has to resort to taking one of the many NSAIDs available in the market. The plus point is that these medicines are very potent anti–inflammatory agents and also have great analgesic (pain relief) properties. The downside is that they do not benefit the disease status or outcome in any way. There is not much to choose between different agents and it is usually the physician's fancy that decides which NSAID should be used. A hit-and-trial approach usually helps one reach a decision as to which agent is best suited to a particular patient. Newer NSAIDs are coming into the market and these need to be given in a single daily dose, helping patients to comply with the treatment.

The major side effect seen with the NSAIDs is upper gastrointestinal bleed. It is seen most often in older female patients.

The only way to avoid this dreaded complication is by co-prescribing antacids and if required, H_2 antagonist medicines, like Ranitidine. Other side effects though seen less often are rashes, fluid retention and oedema of the body, kidney or liver toxicity and flaring up of asthma.

DMARD *(Disease Modifying Anti-Rheumatic Drugs)*: This group is usually referred to as the second-line drug therapy and is added with an appropriate NSAID in an optimal dosage format for two to four months, if this group fails to control the signs and symptoms of active inflammatory process of the disease. These are agents that need to be used with caution as they have serious side effects. Their role in relief from pain, stiffness and swelling over a period of time is well established, though the initial response is not encouraging.

Antimalarial: Used as a second-line medicine along with NSAIDs, it is seen to give good results in about 50 per cent of the patients. If given for four to 12 weeks, an assessment of the benefits can be made. Usually given for not more than 10 months, in a year, it could cause nausea, diarrhoea, haemolytic anaemia and at times, damage to ears. In some cases it gets deposited in the cornea (eye) causing visual problems;

fortunately, the problem disappears on stopping treatment. A rarer yet more serious side effect is retinopathy, causing irreversible visual impairment; thus it is imperative that patients on chloroquine should go in for check-ups. One could use:

- Chloroquine phosphate - 250 mg daily
- Hydroxychloroquine sulphate – 200 mg twice a day

Gold salts: An oral gold salt called Auranofin is currently in use. This could cause mouth ulcers and diarrhoea, but the more dreaded side effect is bone marrow depression. Patients should get regular haemogram and urine analysis done.

Sulphasalazine: Possibly, the most effective of all the DMARDs available, it could cause nausea, vomiting and gastric irritation. Enteric-coated preparations, available now, could help cut down the gastro-intestinal symptoms. Toxic to the liver, it could also cause megaloblastic anaemia. Patients should get liver function test and haemogram done regularly.

Penicillamine: The long list of side effects is a deterrent, therefore not my choice of a regular medicine. It could cause nausea, vomiting,

fever and proteinuria; rare side effects are skin related as in pemplugus, autoimmune diseases like SLE, nephrotic syndrome and Good Pasteur's syndrome. A sharp decline in blood cell count with a marked decrease in platelet count is another dreaded side effect. This is definitely not one of my preferred medicines.

Methotrexate is being discussed last in DMARDs as it is the preferred medicine, especially in rheumatoid arthritis, if other drugs like Sulphasalazine fail. The best thing is the quick response, appreciable in weeks rather than months. This medicine could rarely cause bone marrow depression or altered liver function test, but could cause acute infections. This remains one of the safer bets.

To use or not to use — corticosteroids: A lot has been written and talked about corticosteroids, yet there are cases where only a corticosteroid would work. It is useful in acute exacerbations not responding to the usual regime and in patients with systemic components like arteritis, scleritis or pericardial involvement.

Side effects are many and need to be watched out for, with weight gain and osteoporosis being common. Calcium supplements should

be given concomitantly. Prednisoline in the dosage of 5–7.5 mg given after breakfast could help prevent suppression of hypothalamic-pituitary–adrenal axis.

Immunomodulators: As rheumatoid arthritis is known to arise from immune–related causes, immunomodulators of all types have been used with, of course, variable results. The commonly used medicines of this group are:

- Azathioprine
- Cyclophosphamide
- Cyclosporin

All these medicines work on the immune system, often leading to bone marrow suppression, thereby rendering the patient more prone to secondary infections. The liver is at special risk as are the gonads, thus these medicines are to be used with great caution in younger individuals. The group needs to be used under expert medical supervision and regular laboratory investigations are essential.

Surgical interventions: Though discussion on surgical procedures

would not be of great value to most readers, yet a basic discussion would be in place. Surgical procedures would be required in cases where pain does not abate, despite all medical steps, as in carpal tunnel syndrome or in flexion deformities. In these cases, synovectomy of the wrist and the tendon sheaths of the hands is a great help. At a later date, when the disease could have caused joint deformities, reconstructive surgery with or without implants could be tried. All in all, surgical procedures might not serve the patient to a very great extent, but with minor procedures, pain relief and a greater degree of movement could be anticipated. However, the benefits of such surgical procedures have to be weighed thoroughly in consultation with the rheumatologist and possibly a psychiatrist.

Disease cycle

Most people who develop rheumatoid arthritis can carry on their professional activities. Only a tenth of all diagnosed patients of rheumatoid arthritis have a severe, crippling form of the disease. It would also depend on the patient's response to medication and, of

course, his psyche. How well the patient accepts the disease process and how much and how actively he cooperates with the medical provider would influence the outcome of the disease. Claims of treating the disease sound far-fetched but, yes, good management of the disease could prevent serious joint deformities and systemic problems.

Juvenile chronic arthritis

When young children suffer from chronic inflammatory arthritis, it is called Still's disease. Though recent studies have sub-grouped juvenile arthritis into five distinct sub-groups, for the sake of simplicity, I will discuss these under the head of Still's disease. This could begin at an earlier age (one to five years) with systemic symptoms like enlarged, painful lymph nodes with enlarged liver and spleen with fever, muscle and joint pains. Such children also show retardation in growth, weight loss and severe multiple joints involvement. Other presentations are also seen.

Management

The problem of arthralgia in young children restricts physical activity in the formative years. The physician has to balance the periods of articular rest and exercise schedules. Best results are achieved when care is taken to prevent flexion deformities of the knees and the hips. A keen physiotherapist should be associated with such children to get optimum medical benefits. The controversy of Reye's syndrome caused by aspirin in children below the age of 12 years is surprisingly sidestepped in Still's disease, yet it is still recommended. Other NSAIDs can be prescribed with caution. The fear of growth inhibition by corticosteroids in children can be managed by prescribing an alternate day regime. Children with eye symptoms and severe systemic presentation respond very well to corticosteroids. Immunomodulators are rarely used and the role of surgery is also limited.

Gout

Gout or gouty arthritis is a disease characterised by inflammatory arthritis seen in males after puberty and in post-menopausal females. In this condition, serum uric acid levels usually are above normal levels (0.42 mmol/L in adult males and 0.36 mmol/L in adult females) causing deposition of monosodium urate monohydrate crystals in joints, synovial sheaths in tendons and the kidneys. An increase in uric acid production or a decrease in its excretion causes raised serum uric acid.

Clinical presentation

The first joint or the metatarsophalangeal joint of the great toe is the joint afflicted first in about three-fourths of the patients. Other joints involved would be the ankle joint and rarely the small joints of the feet and hands, the wrist and the elbow joints. In acute gout, usually the metatarsophalangeal joint of the great toe tends to swell up and become red hot and extremely painful. Fever is a usual feature along with nausea. Attacks resolve spontaneously over weeks, leaving the area itchy and the skin peeling off. The disease has a tendency to recur and one could see repeated attacks, one after the other, especially if there is a history of alcohol intake or dietary indiscretion. Other triggering factors could be trauma or some systemic disorder. Patients could present with tenosynovitis, bursitis or cellulitis. Usually acute attacks resolve completely without any permanent disability but if attacks come repeatedly, bone and cartilage erosion with tophi formation is usually seen. In such joints there could be severe physical deformities and functioning of the joints is hampered. The diagnosis is

more clinical than laboratory assisted. A raised uric acid level with no symptoms of gout is not cause enough for initiating treatment. The diagnostic confirmation is done by demonstration of crystals (needle-shaped) of urates in the synovial fluid.

Treatment

Pain, swelling and redness can be taken care of by using an appropriate dose of NSAID. Indomethacin and Naproxen are the preferred drugs. One must avoid use of diuretics in such cases. Colchicine is very efficacious but the dreaded side effects of blood diarrhoea and severe emesis limit its use.

Prevention

Once an acute attack has abated, one could make an endeavour to lower serum uric acid levels by:

- Medication
- Dietary precautions

Medicines used are:

Allopurinal: This is the drug of choice for lowering the serum uric acid levels. Initially, one might require Colchicine or one or the other NSAIDs as initiating treatment with Allopurinal could exacerbate an acute gouty arthritis. It is a safe drug with minimal side effects.

Uricosuric agents like Probencid are used to lower uric acid levels thereby averting acute episodes. This can also help in reducing the size of tophi. One could use Probincid or Sulphinpyrazone.

Dietary precautions

Alcohol is one factor which could trigger an acute attack. High proteins should be restricted. Patients who are overweight would do well to shed a few pounds to get the best results. Surgical intervention is rarely required these days, thanks to effective medicines being available. Only in cases of large tophi, a surgeon's help would be solicited.

Ankylosing spondylitis

This is chronic, inflammatory arthritis seen in the second or third decade, usually in males (4:1 male–female ratio). It involves primarily the lower vertebral column, especially the sacroiliac joints. Most young males presenting with recurrent episodic low back pain and stiffness should be suspected of suffering from ankylosing spondylitis. It is seen in about 0.5 to 0.8 per cent of the population.

Presentation

Most cases present with recurrent low backache and stiffness. Some

patients present with symptoms of iritis (eye disease). One could have pain in the chest which increases on deep breathing. Pain in the foot and the sole (plantar fascitis) and pain in the back of ankle (Achilles tendinitis) could be other forms of presentation. Pain and stiffness of the lower spine with gradual worsening to involve the entire spine is a common presentation. Painful restriction of breathing movements causes a lot of agony among younger males. Only cases which are severe show deformities of the spine.

Laboratory investigations

ESR is more often than not elevated. Rest of the tests are usually normal. The diagnosis is usually clinched by skiagrams of the lumbo-sacral spine. The typical finding is termed as 'bamboo spine' in which there is bone formation in the longitudinal ligaments of the spine. Osteoporotic changes are usually appreciable.

Management

The patient needs to be explained the prognosis of the disease and

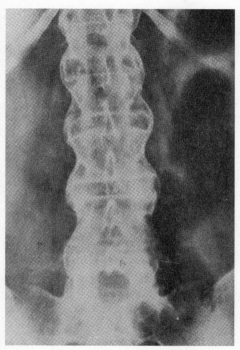

Ossification of the lumbar or
'bamboo' spine.

that his commitment to the treatment would be most rewarding. Exercises and a physically active lifestyle would be helpful. NSAIDs are a great help as they help reduce the pain and stiffness, thereby allowing the patient an active lifestyle. Sulphasalazine has shown great promise but it alters the peripheral arthritis element. In cases of uveitis, oral steroids are of great help. Patients with plantar fascitis do respond to intralesional corticosteroid injection, i.e. at site injections. Surgery in rare

cases may be contemplated, especially where the hip element compounds the disease process.

Rare cases show severe forms of this disease causing deformities. Almost three-fourths of all patients lead an unremarkable life.

Osteoarthritis

Though our ancient scriptures say that a human being is blessed to live a hundred years, Nature does not seem to agree. As a human being turns thirty, one sees a host of degenerative changes in one's joints. One such disease complex is OA (osteo-arthrosis) or degenerative joint disease. Though both sexes seem to show a similar incidence, women tend to suffer from a more severe form of osteo-arthrosis. An interesting fact is that different races show a varying incidence of primary joint involvement.

Types

There are two types of spondylitis:

Primary is where the cause of OA is not discernible or clear.

Secondary is one, where one can be sure of the cause of degenerative changes like a systemic disorder or a local (joint-related) cause.

Osteo-arthrosis of the hip can usually be traced to a developmental

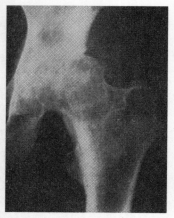

Osteo-arthrosis of the hip.

abnormality causing congenital dislocation of the hip. Also, post-injury imperfect healing (malalignment of the joint surface) can be a definite cause in certain other cases of OA of hip. It is said that in these cases of a recognisable local cause, contact of the different surfaces of the joints is less than perfect, thereby causing more wear and tear of the joint as most of these joints allow a mechanical stress–induced trauma and further destruction.

Joints can also suffer damage because of generalised or systemic diseases. Of these, crystal deposition disorders could cause damage to the joint cartilage by acromegaly or gigantism causing joint cartilage to grow excessively, thereby creating an incongruous joint structure leading to OA. Other rare diseases are Paget's disease, Gaucher's disease and alkaptonuria.

Normal cartilage		Abnormal stress and strain
		↓
		OA
		↑
Normal stress and strain		but cartilage abnormalities

Presentation

It is usually restricted to one or only a few joints being involved in most cases. Common joints involved are:

- Spine
- Hips
- Knees
- Hands

Primary generalised OA

Nodal involving the terminal finger joints

↓

develop gelatinous cysts or bony out-
growths on the dorsum, which is
common in middle-aged females

Non-nodal
- seen equally in both sexes
- terminal finger joints rarely involved
- hip/knees involved more often

Almost all cases of OA present in a very insidious fashion. Pain is
usually very mild initially, increasing on using the joint and almost
disappearing altogether on resting the joint. As the disease progresses,
the intensity and duration of pain after joint movement becomes
accentuated. In this stage there is some pain in the affected joint

throughout. At the same time the movement that the joint allows starts becoming restricted and painful. Simultaneously the muscles around this joint go into a spasm, thereby making the pain more severe. On putting your hand on the joint during movement, one can hear a crackling sound, called 'crepitus'. As the joint starts to degenerate under the stress and strain, the joint starts showing signs of fluid effusion outside the joint space. Slowly and gradually the muscles around the involved joint show muscle wasting, thereby compounding the problem.

Nodal osteo-arthrosis

It is usually seen in middle-aged females affecting the terminal inter-phalangeal joint (the last joint of the fingers). Small bony outgrowths appear in these joints causing Heberden's nodes. There could be pain, swelling and deformity of these joints. This could then progress to the proximal inter-phalangeal joints, the joints of the thumb, wrist, the knees and the hips. This is seen to run in families and has a strong

hereditary factor. Osteo-arthrosis of the knees is a common ailment seen in women and often co-exists with obesity.

Laboratory investigations

All blood tests show normal results. A synovial fluid study shows high viscosity and is usually colourless and clear with a low cellular count (200-400). Radiological assistance is rewarding and shows a reduced joint space with formation of osteophytes. Advanced osteo-arthrosis shows bone sclerosis and at times, cyst formation.

Management

As in all cases of arthritis or arthralgia, the element of patient education is very important, as this ensures full and profitable participation of the patient. The basic aim of treatment should be to relieve pain, improve joint mobility and functioning, thereby putting the patient's mind and body at rest. At the same time, the patient needs to understand that avoiding trauma and stress to the joint would help. The patient needs to be educated about exercises for muscle strengthening and

maintaining joint mobility. The choice of pain-killers has to be intelligently made. NSAIDs, which cause less nausea or gastric irritation, need to be used if and when required as they have no role to play in the disease process. Chondroprotective medicines, such as glyco-samineglycans, etc. are used but their role needs to be studied further. In case of isolated knee osteo-arthrosis, intra-articular or peri-articular injections of corticosteroids are given with good results as far

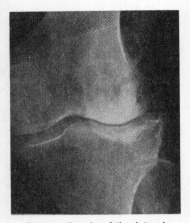

Osteo-arthrosis of the lateral
compartment of the knee
superimposed upon knock knee.

as pain relief is concerned. This gives good results in early/not very late osteo-arthrosis of the knees.

Surgical intervention

Surgical procedures, especially in advanced cases of hip and knee osteo-arthrosis do show encouraging results.

Indications for total knee replacement:

Osteo-arthrosis involves the entire knee, where there is fixed deformity and an inability to walk or loss of balance or inability to stand from a sitting position, causing incapacitating pain. It can also be done in severe or end stage rheumatoid arthritis.

It is usually preferable that the patient is in the sixth decade and during post-operative care, he is advised to avoid weight gain and

major trauma or injury to the joint. A strict exercise schedule should be adhered to. Complications could arise because of implant failure.

Hip replacement surgery is needed in advanced cases of osteo-arthrosis of the hip and also in younger individuals with major trauma to the hip joint. There could be a need for a complete joint replacement or a partial procedure. In partial procedures, one could replace only the head of the femur (the long bone of the leg) or the femur head is attached with a cup which fits into the acetabulum. Patients are advised not to gain weight and be careful to avoid trauma to the hip joint. As more and more research goes into this surgery and the implants, success rates appear to be encouraging. Nearly 90-95 per cent of such surgical procedures give positive results, especially if the patient selection is judicious.

Osteoporosis

As the average lifespan of a human being increases, certain aspects of his health feel the need for a very focused attention. One such problem which is slowly and gradually attaining gigantic proportions is the menace of osteoporosis. It is a disease primarily seen in older women and is labelled as senile osteoporosis. There are other causes which are by far very rare.

Presenting symptoms

People, especially women after the fourth decade, present with severe backache. There could also be cases of repeated fractures with the mildest of trauma. Certain lifestyle features could predispose one to this condition. The common causes are listed below:

- *Inactivity:* Women who are less active are both at a risk of developing osteoporosis and making it worse. It is imperative to do some physical activity to avoid the occurrence of osteoporosis. Women who are less mobile because of other conditions like osteoarthritis or rheumatoid arthritis show a marked osteoporosis, thus complicating the disease process.

- A poor calcium intake could be one of the causative factors. The complex relationship of calcium intake, calcium absorption and calcium utilisation and the role of vitamin D_3 in its uptake is being studied extensively.

- As the condition is most commonly seen in post-menopausal women, a lack of oestrogen has also been implicated as a cause. Most old people show evidence of osteoporosis with the number

being almost one in every three women in the sixth decade suffering from senile osteoporosis.

- Rare causes could be endocrine disorders, developmental diseases, nutritional deficiency and bone marrow diseases.
- Idiopathic osteoporosis occurs at a younger age where one cannot find any immediate cause.

Laboratory investigations

People with fractures can easily be diagnosed once an X-ray plate is viewed, but a lot more patients are diagnosed when they get an X-ray done for other reasons. Bones under view show a decrease in density and this is more pronounced in the pelvis and the spine. The head and the neck of the femur (the long bone of the leg) are also used as reference in bone density tests.

Bone densitometry (BDM) is a good indicator of bone health and gives us a good idea of the chances of fracture. If the bone density is 10 per cent less, there is a 1.5–2.5 times relative increased risk of fracture of that site. Hence bone density measurements at multiple

sites are done to get a better idea of the patient's bone health.

Management

Dietary care becomes extremely important. The intake of calcium, high protein and Vitamin D_3 needs special emphasis, particularly of vitamin D_3. If vitamin D_3 is deficient, calcium absorption and utilisation suffers; hence 1,000–2,000 mgs of calcium per day is recommended.

Patients are advised guarded physical activity like walks and strengthening exercises for joints and muscles to prevent falls and fractures subsequently. In case the patient is bedridden, regular passive exercises must be arranged by a trained physiotherapist. Certain orthopaedic specialists prefer to give Calcitonin. It is still a very expensive proposition but is finding increasing use.

H.R.T. or hormone replacement therapy is a form of treatment prevalent in the West but fortunately it never found acceptance as a regular post-menopausal replacement treatment in Asian countries. Though hormone replacement helps in managing bone resorption and osteoporosis, the side effects are discouraging at best.

Outcome

The earlier a diagnosis is made, the earlier the treatment can be initiated. Most of the times, at menopause, a bone density measurement is advised which could help identify cases early. Most patients of senile osteoporosis do very well with the regime outlined above. Regular bone density measurement is advised and most cases can be halted before it is too late. However, in idiopathic cases seen in younger individuals, results are not very encouraging.

As India sees a raised life expectancy curve, it becomes imperative that regular calcium/Vitamin D_3 supplements are taken by post-menopausal women.

Prosthesis — replacement of joint

When should a joint be replaced? A joint needs to be replaced if it has undergone damage due to disease or trauma to an extent that its normal functioning is seriously impaired. In such cases, the joint is replaced with an artificial joint called a prosthesis. A damaged joint is almost always a painful joint, pain being caused often due to cartilage damage. This pain could be severe enough, forcing the patient to restrict the movement of the joint. Though rest would bring about an analgesic benefit (the element of pain reduces considerably) but the down side

is the weakness and disuse atrophy of the muscles and ligaments around the damaged joint. This makes the joint undergo more damage as weakened muscles would call for greater contribution from the already compromised joint. If other forms of treatment fail, then one needs to look at joint replacement as a possible treatment form.

Pre-surgical workup constitutes physical and psychological assessment. Basic biochemical tests are undergone and the patient should be explained the benefits and drawbacks of this procedure. For better post-surgical results, the patient should be prepared mentally for it is a major event in his/her life. A patient well prepared by the surgical team, rallies better and has less problems post-surgery. The surgical team prepares for the basic procedure deciding on the nature of the implant, etc. It is imperative that the patient is made to stay active and primed up with a strict exercise schedule and good dietary care. One must take into confidence other medical specialists attending on the patient as his/her age would demand other organ system stresses to be managed by relevant consultants. A well-planned and thought-out post-surgical rehabilitation with the patient actively participating

in the planning stage should help in recovery being both quick and reassuring.

A lot of research, both in the laboratory and on patients, has given scientists knowledge to make better, cost-effective and longer-lasting artificial joints or prosthesis. Usually, a prosthesis consists of two parts — a metal component that snugly fits into a matching, tough plastic component. Stainless steel, titanium and alloys of chrome and cobalt are the usual metals used for prosthesis. The plastic is usually polyethylene which is sturdy, durable and shows no wear and tear on long use. To keep the artificial joint in place, plastic bone-cement is used. This works as an anchor.

The procedure is technical and difficult to explain in ink. All the same, the internet has been such a spoilsport that the thirst for knowledge about medical topics seems to grow amongst laymen. At times, when patients walk into my chamber, I am taken aback at the amount of acquired knowledge about diseases they think they have. I am glad most people do not have what they think they have, as thinking about the worst of diseases is in itself a great affliction. Okay, let's move

on to some boring surgical details. The procedure is done under general anesthesia. If the hip is to be replaced, a right-sized prosthesis is decided upon. The artificial joint has a metal ball attached to a metal stem which replaces the damaged part of the hip joint. The stem of the prosthesis is fitted into the upper end of the femur. A plastic socket is then placed and implanted into the pelvis, thereby replacing the entire ball-and-socket contraption which Nature had rendered painful. In the case of the knee, which accounts for a major share of joint replacement surgeries, a knee-joint-shaped metal component with plastic surface is implanted. The sheer imagination of the earliest prosthetic surgeons makes one marvel at the human mind and what it can achieve if it works in the right direction.

Let's not think of the consequences in case it does not work in the right direction. After all, let God also take some blame for gifting a thing like a brain to all and sundry. Other joint replacements are done, though rather rarely. A good surgical procedure needs to be followed up by even better post-surgical care and coordination to make it a truly successful venture for the patient. One needs to start using the

replaced joint at an early date, possibly the second post-operation day. Of course, the need for a walker or a cane or crutches would persist for quite some time. The next pressing problem is analgesia. Pain in and around the joint would be a bone of discontent with the patient complaining about it and the doctor trying to side step the issue or just ignore it. I do believe that pain relief comes in slowly, but if need be and usually, there is a great need for good, effective pain management for a few months. Exercise comes in next; here, of course, the roles reverse. The doctor complains of lack of exercise and the patient seems to side step or avoid the issue. Herein, comes the pre-operative patient counselling and exercise schedule which encourages the patient to go for a rewarding exercise schedule later on.

One can then go on to walking on a regular basis or say, playing golf, etc. More active exercises likes tennis or running needs to be avoided. The extent of joint movement and the extent of mobility would depend on a whole lot of parameters.

I'd like to keep the list of complications short and sugar-coated lest a lot of prosthesis candidates get discouraged to go ahead with the

procedure. As I always tell my patients, if you read any literature about medicine, you will never be able to take a pill without thinking the worst; so is the case with surgery. Thanks to the legal eagles, a procedure needs to be explained and complications, however rare or insignificant, have to be explained to the patient, his attendant, his well-wishers, etc. Most cases do extremely well and have a non-eventful post-surgical phase. One out of 10 cases could show some minor complications. The common complications that may occur are stated below.

- *Infection:* Infections are the bane of all surgical procedures, as they could involve the skin or the deeper tissues. At times, infection around the prosthesis could really be troublesome. Most infections can be treated successfully with antibiotics. Any pus in the infected area can be cultured for microorganisms and the specific antibiotic can be identified and used to thwart the infection.

- *Blood clots:* Any surgical procedure which entails some element of bed-rest, especially in the not-so-young population, could get complicated with blood clots in the deep veins of the leg. This could then cause sluggish return of venous blood and present with

pain and swelling in the thigh or the calf. The most important preventive measure is exercise. Try and make the patient move around at the earliest. Elastic stockings also help. In case there is a suspicion of blood clot, it could be confirmed by blood tests and Doppler study of the deep veins of the legs. Treatment is in the form of regular medication to keep the blood thin enough to prevent clotting.

- *Dislocation*: Rarely, does the prosthetic ball-and-socket joint dislocate or come off the socket. This can be relocated. After this process, a support or brace is required to keep the joint in place.

- *Prosthesis breakdown:* Breakdown of the prosthesis, either the metal or the plastic part, could mean revision surgery to correct the prosthesis.

- *Nerve injury:* Complex corrective surgery, especially for shortening or lengthening of the limb, could cause some amount of damage to the nerves. These nerve injuries usually recover within four to six weeks. The patient needs to be told the whole truth about such an event as nerve injuries could cause pain or lack of function

of the part involved. All in all, about one-tenth of all replacements face some or the other complications but as stated earlier, most such problems can be easily managed and recovery achieved.

How long would a prosthesis work — This is a very common question asked. Most replacements work very well for almost a decade. After this period, there could be a need for a new prosthesis to be put. Younger patients, should be properly explained on this issue. With advancement in prosthetic material and architecture, improved surgical techniques and greater experience acquired by working on a large number of patients, the outlook seems brighter. A time will come when this surgery will be easier, both in terms of cost and effort and have lesser repercussions on the patient's psyche.

Supplement, if you wish

I am sure one would be surprised to see an entire chapter dedicated to what's good for an arthritis patient as far as diet and dietary supplement go! Of course, studies of great depth in this field have not been conducted till date, but I'm sure, soon enough we will have a rash of such studies. Indigenous Indian medicine does have a very exhaustive list of foods that are good as well as foods that are taboo. For the convenience of the reader, I'll give you a mix of what is considered right in both parts of the world. Let's talk about calcium first.

Calcium: As everyone knows, it is what makes up bones and teeth. An average dietary supplement varies with age and sex. Young children, pregnant women and post-menopausal women require more calcium as compared to others. Old women require 1200 milligrams of calcium daily — a poor intake predisposes to weak bones or osteoporosis.

Dairy products, especially milk, have high calcium content. Vegetables like broccoli, cabbage, cauliflower also have adequate levels of calcium in a form which the body can utilise. Calcium can be utilised by the body better in the presence of Vitamin D.

Vitamin D: One element that one can get without making an effort is just simple exposure to sunlight which can prevent Vitamin D deficiency. Actually, sunlight helps convert an inactive form of Vitamin D into the active form of Vitamin D which has a crucial role to play in the health of the skeletal system. As discussed earlier, exposure of skin to sunlight for as little as an hour every week is quite enough. Also, one sees a lot of calcium tablets with Vitamin D_3 added on, but one must not forget that Vitamin D_3 is oil based or fat soluble, thus it

gets stored in the body, at times, reaching levels which could be toxic or harmful to the body.

Vitamin C: Vitamin C is a vitamin that was highlighted after its deficiency disease was discovered in seamen as scurvy. Vitamin C has a great role to play as it helps both by acting as an antioxidant and by building collagen tissue (a major component of joint structure).

Free oxygen radicals are known to be the cause of damage to tissues and Vitamin C helps to 'eat up' these damage-causing free oxygen radicals, thereby preventing wear and tear of the body. The daily requirement of Vitamin C is about 50-60 milligrams, which one could get from a whole range of citrus fruits like oranges, sweetlime, fresh juice, etc. The Indian gooseberry (*amla*) and Chyvanprash are rich sources of natural Vitamin C. This Vitamin, like the B group of vitamins, is water soluble and thus has no stores in the body. Hence there is a need to replenish the stores. Other fruits like melons and strawberries are good sources. Vitamin C tablets are available as single vitamin supplements or in multivitamin tablet formulations.

Other vitamins: Surprisingly, as more and more information is available, balanced food and vitamin supplements seem to be gaining more importance and fortunately more acceptance. Vitamin E is another antioxidant like Vitamin C and thus helps in preventing age-related oxidative damages. Though vegetables have some Vitamin E, most of it is lost in cooking. Cooking in Vitamin E-rich oils, like soyabean oil or canola oil, could help the body get a good part of its daily requirement. Nuts, especially almonds, could give enough Vitamin E as they are richly endowed with Vitamin E.

Vitamin B has a role that is still considered less important in arthritis.

Omega 3 fatty acids: The role of Omega 3 fatty acids in joint health has been a new find. Omega 3 fatty acids help in the production of a chemical called leukotrienes which are the body's indigenous anti-inflammatory agent (which reduce swelling or inflammation) thus helping greatly in rheumatoid arthritis and to some extent in any inflammatory joint disease. Omega 3 fatty acids are available in vegetable oils especially in Canola Oil. It is found in very high amounts in fish, especially trout, tuna, salmon and mackerel. Nuts are another healthy

source of Omega 3 fatty acids as are green leafy vegetables. This completes our list of protective foods that are good for bone health.

Diseases, which are chronic and degenerative where recognised treatment forms fall short of patient expectations, see a rash of treatment formulations, some good and some not so good. Certain over-the-counter formulations which are available and talked about, are being discussed in this chapter.

Glucosamine: Glucosamine is a complex, organic compound which forms a structural component of human joints. This compound shows a lot of promise and has been in vogue. Retrospective studies reveal a pain-killing effect of the compound as well as a protective action of glucosamine. These are products which work slowly and as the disease is usually progressive, it takes even longer to show some benefit. The dosage recommended is 1,000 to 1,500 mgms, but people who are allergic to shellfish should keep away.

Chondroitin sulphate: Most often, chondroitin has been given as a combination with glucosamine. These formulations have been popular over-the-counter and word-of-mouth successes. Their role as a mild

anti-inflammatory and mild analgesic is now established. This is taken for periods as long as six to 18 months. The recommended dosage is 1,200 mg in divided doses. People with diabetes should take it under medical supervision.

Collagen: The usual collagen preparations have an organic component called collagen II, which is a component of joints. This is a preparation which works well in rheumatoid arthritis as it is a natural anti-inflammatory, thereby reducing swelling, pain and stiffness. A recent study also talks about collagen taken as medication, causing the immune reaction-harming joint collagen to slow down, thereby reducing the wrath of rheumatoid arthritis. This product is derived commonly from chicken. The recommended dosage is 50-100 micrograms.

MSM (methyl sufonyl methane): It is a product derived from DMSO (dimethyl sulfoxide). This is a salt which has a doubtful role. It is supposed to reduce swelling, thereby working as a mild anti-inflammatory.

GLA: It is a fatty acid which is found in primrose oil. It assists the

body in production of prostaglandins which fight swelling or inflammation. It is a product which helps relieve pain and inflammation especially in rheumatoid arthritis. Nowadays, it has a role in managing pain of diabetic neuropathy. A short trial is in order.

These are some of the important supplements that would be used for the purpose of treating osteoarthritis and rheumatoid arthritis.

Pain — the painful details

When this small book was planned, we had not conceived this note on pain, its pathways and the sordid details of pain. While reading the usual medical literature that doctors keep getting, I came across a great work, *Challenges in Pain Management – A Way Forward*. This inspired me to write on pain in some detail. Let's first understand how pain is felt?

Once an injured/diseased tissue (through the peripheral pain receptors) picks up a pain stimulus, this message is transmitted through

the first contact point in the central nervous system. From here, the input is passed on to the brain. The brain is actually the centre for perception. Here this signal is understood as a pain signal. This is not all.

The pain pathway

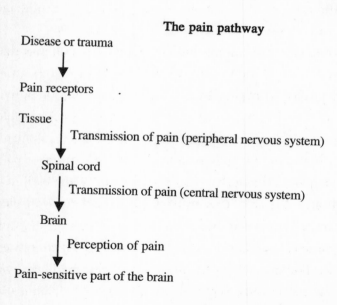

Disease or trauma

Pain receptors

Tissue

Transmission of pain (peripheral nervous system)

Spinal cord

Transmission of pain (central nervous system)

Brain

Perception of pain

Pain-sensitive part of the brain

perception. Here this signal is understood as a pain signal. This is not all. Of course, the person now starts to feel pain. The brain now starts a process of modulation which is carried on by certain neurons which inhibit the pain receptors. Modulation of pain is therefore a message from the brain to the tissues where the pain originates.

Here we come to a very interesting fact. Latest research says that the central nervous system does not always behave like this. In cases where painful stimuli last long and there is a constant bombardment of nociceptors or pain receptors, the central nervous system would perceive greater pain. In simple words, if pain persists, pain gets amplified. The patient therefore feels greater pain even if the intensity of pain remains same; thus the concept that pain management at the earliest is most beneficial and desirable. This amplified pain sensation is called hyperalgesic state. There is another twist to these findings. Stimuli which did not cause pain earlier, could produce pain if pain continues. This is termed as allodynia, which is a troublesome feature. These two phenomena cause more agony to the patient if initially the pain is not handled at the earliest and with efficiency.

Normal state

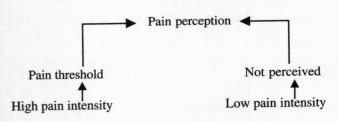

Pain perception

Pain threshold

High pain intensity

Not perceived

Low pain intensity

Hyperalgesic state

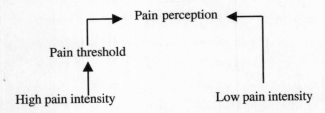

Pain perception

Pain threshold

High pain intensity

Low pain intensity

Considering all these facts, the British Pain Society and the Royal College of General Practitioners (2004) issued five pledges to show solidarity with patients living with constant pain:

- Patients should be actively involved in the management of their pain.
- There should be timely assessment of pain.
- Access to appropriate management and support.
- We should be informing our patients and thereby increasing compliance.
- Access to adequate resources and facilities.

Types of pain

- Somatic – arising from skin, joints and muscles.
- Visceral – arising from internal organs.
- Neuropathic – arising from injury to peripheral nerves, spinal cord, etc.

 A few technical terms to describe symptoms and signs of the sensory pains are enumerated herewith:

- *Hyperalgesia* – increased or exaggerated response to painful stimulus.
- *Hyperaesthesia* – increased or exaggerated response to stimulus of touch.
- *Allodynia* – when one perceives pain even to a light, mechanical stimulus.
- *Hypoalgesia* – a condition of reduced pain perception.
- *Analgesia* – when there is no pain sensation. A word of caution here; pain is also a protective mechanism as when you get an injury, it is the pain stimulus which helps you to withdraw and prevent further damage or injury. So, analgesia is not a boon; it is a grave risk.
- *Causalgia* – a sensation of severe burning pain usually seen after a peripheral nerve injury.

Pain characteristics and management

Somatic pain: Pain is secondary to a painful stimulus. These pains are usually very well localised and arise from injury to skin, joints or muscles.

Such a pain responds very well to the usual NSAIDs.

If the pain is severe and not managed effectively by anti-inflammatory drugs, narcotic analgesics could be tried.

Visceral pain: Pain caused by inflammation of internal organs is poorly localised and usually referred. Such pain is usually managed by narcotic analgesics.

Neuropathic pain: This pain is caused by some damage to nerves. Pain arises with no obvious painful stimulus. This pain is often described very vividly by patients as shooting, electric, burning, lancinating, pins and pricks and could start without any provocation. Such pain usually becomes chronic and is then managed by anti-depressants, anti-convulsants and psychological management.

Some common analgesics with their dosages are listed below:

Name	*Dosage*
Acetyl salicylic acid	650 mg
Acetoaminophen	500-650 mg

Contd.

Ibuprofen	400 mg
Naproxen	250-500 mg
Fenoprofen	200 mg
Indomethacin	25 to 50 mg

Exercise: if there is need

Yes, definitely exercise. The need to exercise cannot be understated. It is most important to understand that exercising is not going to cause more pain in a patient with arthritis but in fact would help improve the patient's condition. Let me explain scientifically how a joint suffering from osteoarthritis would benefit from exercising.

To understand this one needs to understand that the cartilage inside the joint has no blood supply and has to depend on the fluid around the joint for its nutrition. As the joint moves, the cartilage gets more

nutrition from the surrounding fluid which makes the cartilage healthier. Thus, one needs to exercise a diseased joint but a word of caution here — the exercise schedule and intensity must be decided by experts.

The other benefit of exercising intelligently is the strengthening of the muscles which work on the joint. As the joint muscle becomes stronger, the stress on the joint per se reduces, thus preventing further damage to the joint.

Latest studies also talk of the chemical produced by the brain when you exercise. These 'happy' hormones make you feel happier, thereby reducing stress, anxiety and depression which set in as the arthritis progresses. Also, it is now confirmed that exercises raise your pain threshold, thereby meaning that the pain stimulus needs to be stronger to feel the pain.

If despite all this, an arthritis patient does not exercise, it simply means be does not want to participate in improving his health status. This could mean that the patient needs to be handled psychologically.

Medical terms

As our knowledge increases, so does the corpus of vocabulary. I would like to explain in some detail the terms which doctors use with their fellow care-givers without the patient understanding anything. Let us acquire some knowledge of these terms.

Passive exercise : An exercise is in which someone else and not the patient puts a joint through the motion. Thus, it is an exercise in which the joint actually does not move of its own free will.

Active-assistive exercise : In this the physiotherapist advises and, at times, assists the patient during therapy. The best aspect is that the

exercise is done under supervision with no scope of error or skipping.

Isometric exercise : Here the primary aim is to prevent any stress on the joint with minimal joint movement. The muscle is contracted and the exercise is repeated five to ten times in a day.

Isotonic exercise : This exercise involves movement of a joint to the maximum with the muscle undergoing both contraction and shortening. In most cases of arthritis, one needs to avoid such an exercise.

Heat therapy : Most patients of arthritis resort to various means or take heat treatment. Heating pads, infrared lamps, are some of them but the age-old hot water

bottle still provides solace to many a painful joint.

Ice pack : That change is inevitable, everyone knows and understands. Possibly that is why a lot of people suggest cold compress with ice packs as a therapeutic measure. This is a highly debatable issue though it seems to be pretty minor. Diplomacy pays, at least in this context.